The Shire Book

TWENTIETH
TIL

Hans van ~~Lemmen~~
and Chris Blanchett

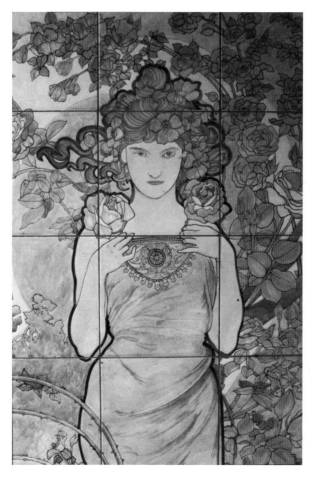

rare Art Nouveau tile panel designed by the Czech artist Alphonse Mucha for Pilkington's Tile & Pottery Company and painted by their in-house artist Thomas F. Evans for the 1901 Glasgow Exhibition. It is part of a series of four panels known as 'Les Fleurs', depicting women personifying flowers. Illustrated here is 'The Rose', which is still in situ in a shop entrance at 713 Great Western Road, Glasgow.

Published in 1999 by Shire Publications Ltd,
Cromwell House, Church Street, Princes Risborough,
Buckinghamshire HP27 9AA, UK
(Website www.shirebooks.co.uk).
Copyright © 1999 by Hans van Lemmen and Chris
Blanchett.
First published 1999. ISBN 0 7478 0401 X

British Library Cataloguing in Publication Data:
Van Lemmen, Hans
Twentieth century tiles
1. Tiles – History – 20th century
I. Title II. Blanchett, Chris
738.6'0904
ISBN 0 7478 0401 X

Cover: (Top) A hand-painted tile with a girl feeding a goose; Henry Richards Tile Company, c.1920. (Centre) A Delft tile panel made in 1995 by Jones's Tiles and showing an orange tree in a flowerpot standing on a ledge of traditional delftware tiles. (Bottom) Detail of a tiled panel made by Paul Scott for the Royal Victoria Infirmary, Newcastle upon Tyne, painted in under-glaze on porcelain with screen-printed in-glaze details, 1998. (Background) A set of silk-screen printed and hand-sprayed abstract tiles by Kenneth Clark Ceramics, early 1980s.

ACKNOWLEDGEMENTS

Several people have been of assistance in the production of this book. In particular we would like to thank Charles Allen, Maggie Berkowitz, Michael Blood, Margery Clinton, Helene Curtis, Bobby Jones, Wolfgang König and Paul Scott. Photographs are acknowledged as follows: Kenneth Clark Ceramics, page 34 (bottom); National Tile Museum, Otterlo, Netherlands, page 8 (top right); the Potteries Museum and Art Gallery, Stoke-on-Trent, pages 10 (top right), 15 (bottom); Marlborough Tiles, page 32 (top); Margery Clinton, page 36 (bottom left); Bobby Jones, page 33 (top left); Paul Scott, page 36 (top). All other photographs are from the authors' collections.

Printed in Great Britain by CIT Printing Services Ltd, Press
Buildings, Merlins Bridge, Haverfordwest, Pembrokeshire
SA61 1XF.

CONTENTS

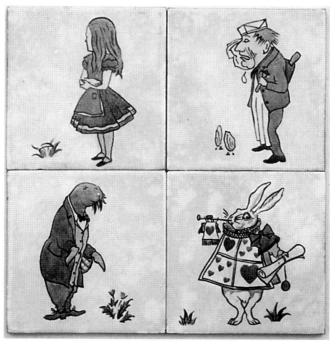

Four tiles from the Dunsmore 'Alice in Wonderland' series made in 1955, based on illustrations by C. F. A. Voysey.

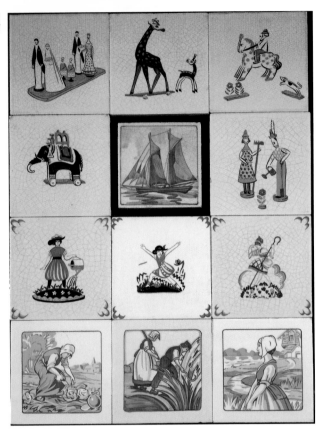

INTRODUCTION

Tile history has tended to focus on periods up to 1900, and the twentieth century has received scant attention. The purpose of this book is to redress the balance and to provide a concise outline of the main stylistic developments, manufacturers and designers of twentieth-century tiles, as well as giving more attention to the work of contemporary tile artists.

When the history of twentieth-century tiles is looked at closely it becomes apparent that four main phases can be distinguished: the period before the First World War, dominated by Art Nouveau; the period between the two World Wars, when Art Deco emerged; the two decades following the Second World War, when abstract Modernist designs were in vogue; and the late twentieth century, when there has been a return to figurative tile designs stimulated by the endeavours of an increasing number of contemporary tilemakers.

Some of the most beautiful tiles were made during the first ten years of the century, when tile manufacturers produced hand-decorated and machine-pressed Art Nouveau tiles with appealing sinuous lines and stunning colours. Tiles made by Mintons China Works,

4

Doulton & Company and Pilkington's Tile & Pottery Company are now eagerly sought after and have become coveted items in many public and private collections.

During the inter-war period new stylistic developments showed a tendency towards abstraction, which culminated in the streamlined figures and geometrical designs of Art Deco. Large manufacturers like Carter & Company, Maw & Company and Henry Richards Tile Company made a range of both figurative and abstract tiles to suit the new taste. The output of these large companies was augmented by the products of small firms like Dunsmore and Packard & Ord, run by talented women who successfully put an intriguing range of hand-painted tiles on the market.

After the Second World War Modernist design dominated the period between 1950 and 1970. In many instances hand-painting and tube-lining gave way to the new technique of screen-printing, which was more suited to the production of abstract designs with flat colour areas. An outstanding designer of this period was Peggy Angus, whose bold non-figurative tile patterns were used to decorate the modern buildings of the time.

In the last two decades of the century the production of decorative tiles underwent a marked revival. There was a renewed interest in figurative design coupled with a revival of past styles such as Victorian and Art Nouveau. More small tilemakers than ever before were active and became increasingly successful in cornering parts of the market with innovative designs that made for a diverse and rich contemporary tile scene.

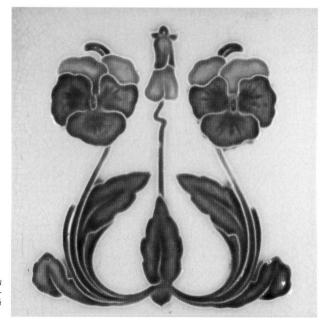

A machine-moulded Art Nouveau tile with pansies painted in translucent glazes; J. H. Barrett & Company, 1906.

ART NOUVEAU TILES

Two tiles by Doulton & Company, London, c.1905: (left) a floral design by W. J. Neatby; (right) an Art Nouveau design.

The heyday of Art Nouveau was between 1895 and 1910. A main event was the establishment of a shop called 'L'Art Nouveau', opened by Siegfried Bing (1838-1905) in Paris in 1895. His success was so great that at the Paris World Fair in 1900 he even had his own pavilion, called 'Art Nouveau Bing', which confirmed him as a major trendsetter for the new style. The popularity of the Art Nouveau style spread rapidly throughout Europe, and every country developed its own version. Art Nouveau was seen by many to be new, modern and progressive, breaking with the historicism of the nineteenth century, and therefore a fitting beginning for the twentieth century. The Art Nouveau style was characterised by tendril-like sinuous lines that were based on floral and botanical sources and flowed freely over the surfaces they were meant to decorate. Figurative panels often included female figures with long flowing robes and hair.

Several prominent tile manufacturers like Doulton & Company, Mintons China Works, Pilkington's and Maw & Company produced panels and individual tiles in the Art Nouveau style that were designed by artists in their own firms or by freelance designers. Doulton & Company in London employed Margaret Thompson, J. H. McClennan and William Rowe, who designed several outstanding Art Nouveau tile panels for hospitals, notably those made for St Thomas's Hospital, London. Panels representing scenes from nursery rhymes and fairy tales were situated in the former Lilian and Seymour children's wards, which opened in 1901 and 1903. Both wards have now been closed and the panels removed, but some of them have been carefully restored and are now displayed elsewhere in the hospital.

More ambitious tiling schemes were created by the Doulton artist William J. Neatby. His calibre as a designer was recognised by his contemporaries. In an article entitled 'Mr W. J. Neatby and His Work' published in the progressive art magazine *The Studio* in 1903, Aymer Vallance, the biographer of William Morris, stated that it was 'the strength of Mr Neatby's work that he is no mere theorist but at once a designer, vivid in imagination, and a handicraftsman who has thor-

Two Art Nouveau tiles, c.1905: (left) by Mintons China Works; (right) by Minton, Hollins & Company.

Two tiles by Pilkington's, c.1905: (left) a machine-moulded tile; (right) a hand-made tile with lustre glazes.

oughly mastered the ways and means of his material'. This can be seen clearly in several of his major tiling schemes such as the Everard Building in Bristol and Harrods Meat Hall in London.

The Everard Building was constructed for the printer Edward Everard in 1901. It has a polychrome tiled exterior celebrating the printer's craft. At the top of the vibrant polychromatic facade is a female figure representing the spirit of light and truth, while between the ground floor and the first floor the printers Johann Gutenberg and William Morris can be seen at their printing presses on either side of an angel reading a book. Strong black lines delineate the coloured figures.

A similar approach can be seen in the interior of Harrods Meat Hall, completed in 1902 and tiled throughout. The extensively tiled ceiling depicts stylised trees, below which there are hunting and animal scenes in circular frames executed in strong colour. The tympanum over the entrance has gold and blue tiles, while the pillars supporting the ceiling have tiles with abstract Art Nouveau motifs, which help to create an opulent interior.

Mintons China Works in Stoke-on-Trent were also important producers of Art Nouveau tiles. One of their most outstanding designers was Léon V. Solon, the son of Louis Solon, the famous Minton *pâte-sur-pâte* decorator. Léon Solon joined Mintons China Works in 1895 and around 1900 produced some outstanding plaques showing female figures in the Art Nouveau style. While Solon's designs were executed painstakingly by hand by means of tube-lining, and were destined for a discerning clientele, Mintons China Works also produced a range of machine-moulded Art Nouveau tiles. Designs with raised relief lines were created on the tiles during the machine-pressing process, and the areas between the lines were filled with colourful translucent glazes. This type of tile was widely used in the porches of houses and in bathrooms and toilets.

Pilkington's Tile & Pottery Company near Manchester was a re-

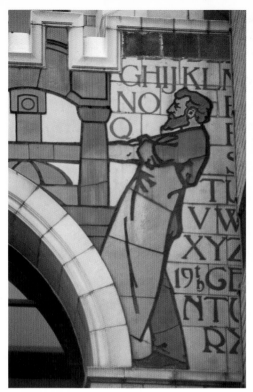
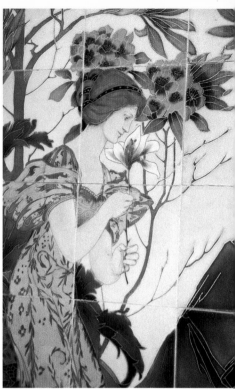

Above left: *Detail showing William Morris at his printing press on the exterior of the Everard Building, Bristol, built in 1901. The facade is covered with Doulton ceramic tile decorations designed by W. J. Neatby.*

Above right: *Detail of an Art Nouveau tile panel designed by Léon V. Solon for Mintons China Works, showing a woman holding a lily; tube-lined and painted with coloured glazes, c.1900.*

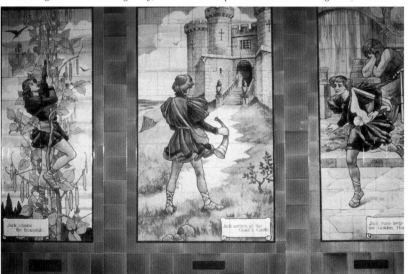

Doulton tile panels at St Thomas's Hospital, London, showing Jack climbing the beanstalk, Jack arriving at the giant's castle, and Jack running away with the golden harp; painted by either Margaret Thompson or William Rowe, c.1901-3.

8

A floral machine-moulded tile designed by Lewis F. Day for Pilkington's, c.1902.

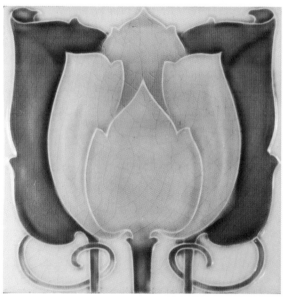

A floral machine-moulded tile designed by C. F. A. Voysey for Pilkington's, c.1902.

lative newcomer to the tile industry compared to Doulton and Mintons. Pilkington's began production in 1892 and by the turn of the century had become established as a formidable tile manufacturer. They commissioned designs from leading figures such as Walter Crane, C. F. A. Voysey and Lewis F. Day, whose tile designs became a standard repertoire of the firm's output. Pilkington's also took part in the Glasgow Exhibition of 1901, where they exhibited four panels called 'Les Fleurs' designed by the famous Czech Art Nouveau artist Alphonse Mucha and executed by the Pilkington's tile-painter Thomas F. Evans. An important commission was the production of tile panels for the City of Liverpool Museum showing the history of

9

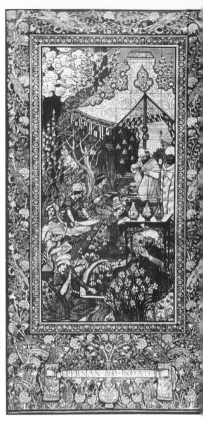

Cartoon for a Pilkington's tile panel entitled 'Persian 800–1600 AD' from a series depicting pottery through the ages by Gordon M. Forsyth for the City of Liverpool Museums, 1914.

pottery through the ages; they were designed by Gordon M. Forsyth in an Iznik/Persian style. A particularly intriguing contract was the supply of lustre tiles for dadoes and fireplaces for the ill-fated ocean liner *Titanic*. Pilkington's also commissioned tiled fireplace designs from the Manchester architect Henry J. Sellers, often decorated with their lustre tiles. One of these fireplaces was illustrated in *The Studio* in 1909.

Doulton, Mintons China Works and Pilkington's were not the only firms to make Art Nouveau tiles. Amongst the others, Maw & Company of Jackfield, near Ironbridge, Shropshire, made high-quality tiles for use in fireplaces, public houses and shops. Some of these were designed by their in-house artist, Charles H. Temple. At the turn of the century some unusual tiles were made by the Photo Decorated Tile Company in Derby; they specialised in transferring photographic images to tiles, some of which have ornate linear borders reminiscent of Art Nouveau. There were also numerous tilemakers in Stoke-on-Trent who made machine-moulded Art

Left: *Detail of a tiled porch in Catherine Street, Crewe, Cheshire. The central panel shows a girl with flowers set within an elaborate linear border and was made by the Photo Decorated Tile Company of Derby, c.1902.*

Below: *A pair of Maw & Company tiles designed by Charles H. Temple, c.1905.*

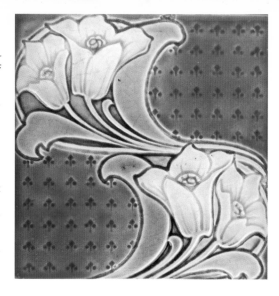

A machine-moulded Art Nouveau tile with swirling yellow flowers painted in translucent glazes; Marsden Tile Company, c. 1905.

Nouveau tiles for the mass market. Examples are J. H. Barrett & Company, T. & R. Boote, Sherwin & Cotton, Lee & Boulton, Campbell Tile Company, and Minton, Hollins & Company. The Art Nouveau tiles mass-produced by these firms can still often be found in the porches and fireplaces of many Edwardian houses throughout Britain.

Not only British Art Nouveau tiles can be seen in Britain. Some prestigious projects were carried out using the products of tile manufacturers from continental Europe. One such is the well-known Michelin Building in Fulham Road, Lon-

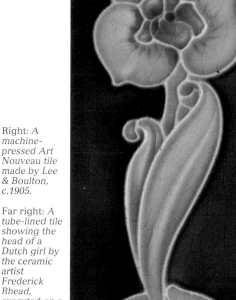

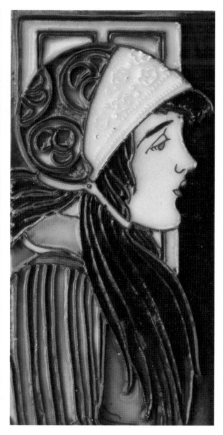

Right: *A machine-pressed Art Nouveau tile made by Lee & Boulton, c.1905.*

Far right: *A tube-lined tile showing the head of a Dutch girl by the ceramic artist Frederick Rhead, executed on a machine-pressed blank by T. & R. Boote, c.1910.*

Above: *(Left) An unusual printed and hand-coloured Art Nouveau tile by Sherwin & Cotton. (Right) A relief-moulded tile by T. & R. Boote. Both c.1905-10.*

Right: *A pair of Art Nouveau tiles by the Campbell Tile Company, originally from Beverley Road Baths, Hull, 1906.*

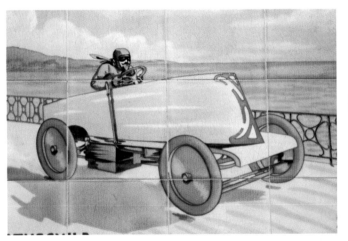

Above: *Detail of a tile panel on the exterior of the Michelin Building, Fulham Road, London, made in 1909 by the firm Gilardoni Fils & Cie, Paris, showing a scene from early twentieth-century motoring history. The panel depicts a road race held in Nice in 1903.*

Right: *A tube-lined and hand-painted Art Nouveau tile depicting a rose, c.1905.*

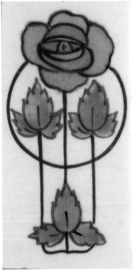

don, which is a prime example of the use of Art Nouveau tiles in the service of commercial advertising. The building dates from 1909 and has a fine display of hand-painted panels depicting famous early cycle and motor races using Michelin pneumatic tyres. The panels were made by the Paris firm Gilardoni Fils & Cie. This foreign scheme must have had a British royal blessing as in the entrance of the Michelin Building there is a very large panel showing King Edward VII, a pioneer motorist, sitting in the back of a motor car.

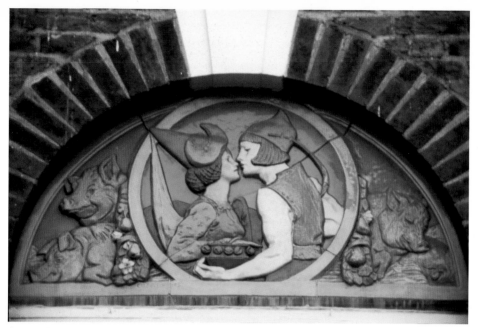

A ceramic panel made by Doulton & Company in the lunette above one of the windows of the Sidney Street Estate, St Pancras, London, designed by the sculptor Gilbert Bayes, 1930, depicting the fairy tale of 'The Princess and the Swineherd'.

TILES BETWEEN THE WARS

The inter-war fashion for plain functional tiling was influenced stylistically by progressive groups of artists, architects and designers from continental Europe such as the Russian Constructivists, the Dutch De Stijl group and the German Bauhaus. They advocated that form should follow function and rejected excessive decoration and ornamentation in architectural design, including decorative tiles. However, not all decorative tiling disappeared. Although walls in the 1920s and 1930s were covered with machine-made plain tiling, there were occasional insets of decorative tiles with abstract or figurative motifs that helped to offset the severe functionalism of plain tiles.

Another important factor was the inter-war design phenomenon called Art Deco. This term (an abbreviation of the French *Arts Décoratifs*) was borrowed from the influential *Exposition Internationale des Arts Décoratifs et Industriels Modernes* held at Paris in 1925. Art Deco tiles showed either patterns with abstract forms of squares, triangles and circles executed in bright strong colours, or streamlined curvilinear and rectilinear figurative motifs of humans, animals, landscapes and ships.

In Britain large firms like Carter & Company of Poole, Dorset, produced an extensive range of picture tiles. Designers who worked for Carter, such as Joseph Roelants, Harold Stabler, Dora M. Batty, E. E. Stickland, Edward Bawden and A. Nickols, showed great artistic merit in the quality of their tile designs. In the early 1920s the Belgian artist Joseph Roelants designed a hand-painted series, the 'Dutch' series, of which there were two versions, 'Coloured' and 'Blue', painted in an in-glaze technique. In the 1930s Harold Stabler

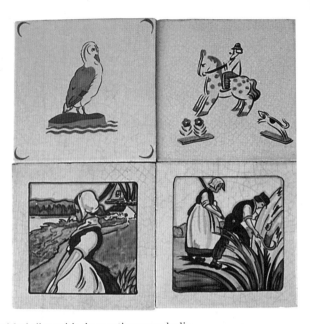

Four hand-painted tiles by Carter & Company, 1930-5: (top left) 'Waterbird' series by Harold Stabler; (top right) 'Playbox' series by Alfred Read; (bottom two) 'Dutch' series by Joseph Roelants.

created a set of stylish relief-moulded tiles with decorations symbolic of London and the London Underground, executed in creamy semi-matt glazes for a number of London Underground stations. In addition to his work for London Underground he designed a series of six 'Waterbird' tiles. Dora Batty made a series of intriguing tiles for younger tastes. The series 'Nursery Rhymes' and 'Nursery Toys' show scenes in simplified outlines that were painted by hand on the tiles for

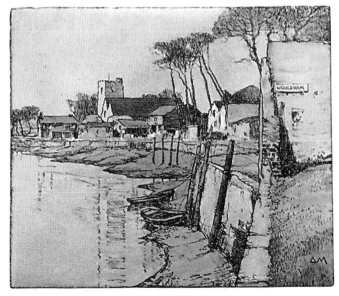

A tile from the Doulton 'Doomsday Book of Kent' series showing 'Wouldham', designed by Donald Maxwell, 1936.

14

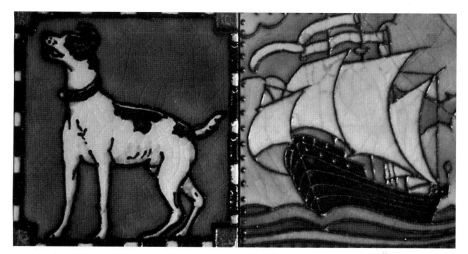

Two tube-lined tiles by Pilkington's, designed and decorated by Edmund Kent, c.1930-5.

use in nursery fireplaces. E. E. Stickland is best known for the 'Farmyard' set showing twelve hand-painted farm animals such as geese, hens, pigs, goats, horses and lambs. This became popular in butchers' shops. In the same vein, A. Nickols created a set of 'Dairy' subjects showing cows and hens, with each subject running over a panel of four tiles. Edward Bawden designed a set of 'Sporting' subjects.

On a different note, the well-established London firm of Doulton & Company became involved with the decoration of the Sidney Street Estate housing scheme in St Pancras, London, in 1930. The sculptor Gilbert Bayes designed a series of colourful ceramic lunettes above the windows to relieve the monotony of the yellow bricks. The subjects chosen were from fairy tales such as *The Princess and the Swineherd*, *The Little Mermaid*, *The Goosegirl* and *Sleeping Beauty*, all executed in frost-resistant polychrome stoneware. This scheme was a successful attempt to brighten the architectural environment of the

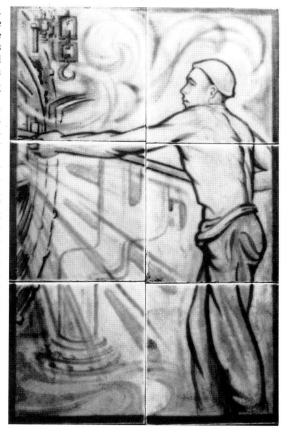

A Pilkington's tile panel with a hand-painted image of a foundry worker, c.1930.

Above: *Slip-trailed Art Deco tiles made by Candy & Company, c.1930.*

Top left: *A tube-lined tile with an abstract design executed in striking black and orange glazes, made by Pilkington's, c.1930.*

Centre left: *A hand-painted tile with a girl feeding a goose; Henry Richards Tile Company, c.1920.*

Bottom left: *A tile with a stencilled decoration of a lamb in a meadow, made by Dunsmore, c.1935.*

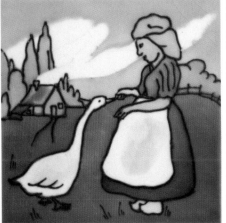

working-class tenants of the Sidney Street Estate.

Maw & Company, Pilkington's and Candy & Company also produced an interesting range of pure Art Deco tiles with geometrical motifs such as squares, circles, zigzags and rising sun designs. Pictorial Art Deco tiles with sailing boats and other scenes were made by Henry Richards Tile Company, A. J. Wade, H. & R. Johnson and H. & G. Thynne. These tiles with their striking designs were executed in strong colours and sometimes lustre and were often used as insets amongst plain tiles in bathrooms and fireplaces.

Apart from the large tile manufacturers, there were also smaller firms who were able to capture a corner of the market. One such firm, Dunsmore, did not make their own tiles but bought ready-made blanks from Mintons China Works, Henry Richards Tile Company and others. The firm was founded by Miss Brace and Miss Pilsbury, who operated from Campden Hill, Kensington, London, and was in business by 1928. They were decorators only and during the 1930s produced some unusual sets of stencilled and aerographed (sprayed) picture tiles depicting fishes, birds and agricultural scenes.

Another tile-decorating firm founded by two women and specialising in picture tiles was Packard & Ord of Marlborough, Wiltshire. Rosalind Ord and Sylvia Packard were both art teachers at the

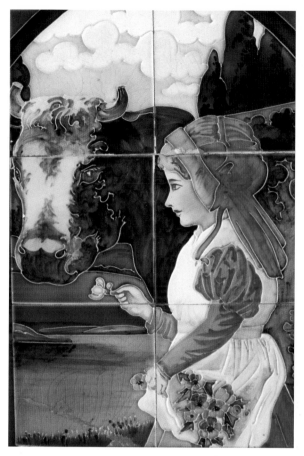

Royal School, Bath, and their introduction to tilemaking came in 1929 when they were asked to design a tile mural for the school. This was installed in 1931. More tile commissions followed, and a small business was set up. At first they bought biscuit tiles from Carter & Company in Poole and, after decorating them, returned them there for firing. A special commission from Lord Iveagh in 1935 for a set of bathroom tiles encouraged them to buy their own kiln and run a more independent business. Sylvia Packard, Rosalind Ord and a third woman designer, Thea Bridges, created a large series of designs of flowers, birds, animals, nursery subjects and human figures. Their small business prospered, but they had to suspend their operation in 1940, after the outbreak of the Second World War.

If the tube-lining technique had been an important part of

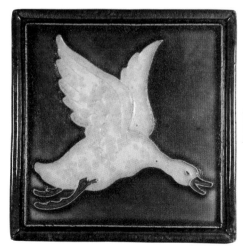

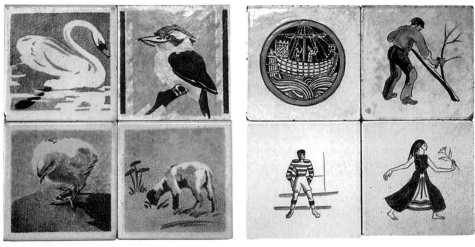

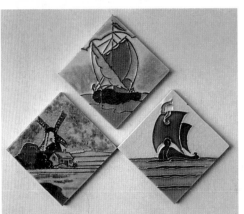

Above left: *Four early tiles by Dunsmore from their 'Bird' and 'Animal' series, c.1935.*

Above right: *Four early tiles from Packard & Ord from the period 1932-8: (top left) 'Fair Life' series, designed and painted by Sylvia Packard; (top right) 'Peasants' series, designed and painted by Rosalind Ord; (bottom left) 'Sports' series, designed and painted by Thea Bridges; (bottom right) 'Dancers' series, designed by Rosalind Ord and painted by Thea Bridges.*

Left: *Three slip-trailed tiles for fireplaces of the 1930s: (top) H. & R. Johnson; (bottom left) Maw & Company; (bottom right) A. J. Wade.*

Below: *A peacock panel by T. & R. Boote, c.1925.*

Art Nouveau tile production, it was carried on as a major tile decoration technique during the 1920s and 1930s. The outline of the design was trailed in slip, producing a raised line, and colourful glazes were painted in between the lines. The firm of J. Duncan Ltd of Glasgow specialised in this technique and created many tile panels for the chain of Buttercup Dairy shops throughout Scotland. All these shops featured a standard panel at the entrance showing a girl feeding a buttercup to a cow. J. Duncan Ltd, too, were decorators only and used machine-pressed blanks made by T. & R. Boote to work on.

Not only British tiles were in demand. Tiles were also imported from continental Europe. The products of the Dutch firm De Porceleyne Fles of Delft were imported by Bell & Company of Northampton, their agent in Britain. The Porceleyne Fles tiles were executed in a cloisonné technique and depict birds, animals, windmills and flowers. Most were designed by the Porceleyne Fles in-house designer, L. E. F. Bodart.

The tiles made by the potter Bernard Leach were one of the great artistic highlights of inter-war tile production. In his studio at St Ives in Cornwall he made tiles from the late 1920s onwards. His stoneware tiles often show primitive animals or Japanese-inspired trees painted in black on an amber glaze and were used in fireplaces or sometimes fire screens. His hand-made tiles and hand-painted decorations

Right: *A panel of three tiles by Lee & Boulton, c.1920.*

Below: *Two tiles made by the Dutch firm De Porceleyne Fles, imported by Bell & Company Ltd, Northampton, for use in their tiled fireplaces, c.1930.*

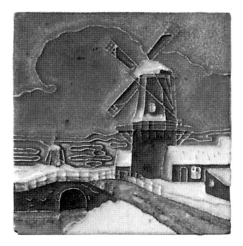
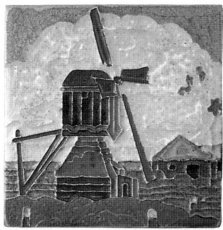

19

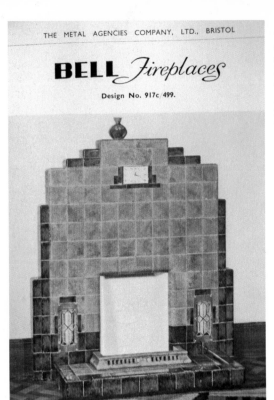

Dawn Grey and Blue Grey, fitted with 6 in. × 4 in. Electric Clock, 16 in. S

were the antithesis of the many machine-made tiles of the period and show the continuing appreciation of hand craft traditions in the twentieth-century machine age.

The Second World War, like the First, was a major interruption for the British tile industry. When tile production resumed after 1945, the designs, methods and production processes of the inter-war period at first continued, but soon major changes came about with the introduction of screen-printing and the rise of the bold abstract designs that became the hallmark of the tiles of the 1950s and 1960s.

An Art Deco fireplace made by Bell & Company Ltd, Northampton, illustrated in the hardware catalogue of the Metal Agencies Company Ltd, September 1937.

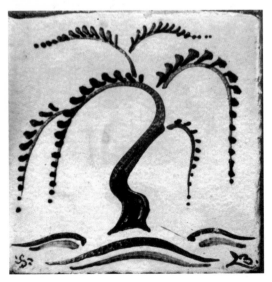

A stoneware tile with a weeping willow by the famous potter and tilemaker Bernard Leach; St Ives Pottery, Cornwall, c.1930.

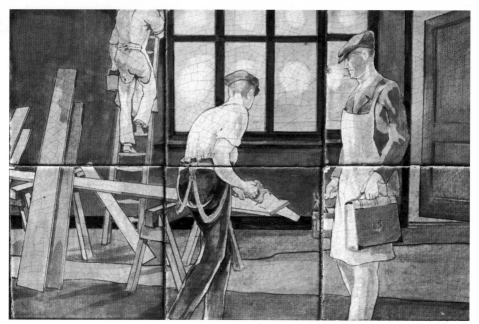

A painted tile panel on the exterior of the shop of F. E. Gillett Ltd, decorators, at 184 Vauxhall Bridge Road, London, showing carpenters and painters decorating a room, c.1930. The tiles were probably made by Dunsmore.

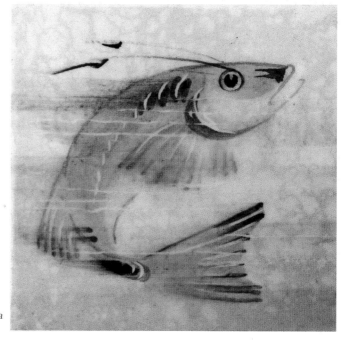

A hand-painted tile with a fish; Dunsmore, c.1930.

Post-war austerity and growth

After the Second World War Britain's housing stock was severely depleted owing to the devastating effects of German air-raids. The government wanted to embark on a major programme of housing construction, but this was slow to begin because funds, labour and raw materials were all in short supply. One solution was the prefabricated house or 'prefab', many thousands of which were constructed in the late 1940s and early 1950s. Few of these originally had tiles, although some had zinc panels printed to resemble tiles fitted in the kitchens and bathrooms.

Tile manufacture had virtually ceased during the war, with tile factories being used for the production of munitions. Machinery that had not been put to other use had fallen into disrepair or been broken up for scrap. As a result, many long-established companies failed to survive the war. These included Lee & Boulton and the Marsden Tile Company. Because of the heavy rate of purchase tax on decorated tiles most immediate post-war tiles were plain white or cream.

As the tile industry began to rebuild, manufacturers had to mechanise their production lines to contain costs. Tunnel kilns had dramatically reduced firing costs shortly after the First World War, but many of the decorative techniques employed were still very labour-intensive. These included hand-painting and the use of tube-lining, which had been popular during the 1930s. As restrictions were relaxed in the early 1950s, tilemakers again turned to producing patterned tiles but sought methods of decoration that lent themselves to mass production. In the early 1950s Carter & Company of Poole, Dorset, set about the difficult task of mechanising the silk-screen process for decorating tiles. To keep production flowing, it was essential that the tiles moved along the production line without stopping, and thus the printing screen had to move along the line at the same speed as a tile, returning instantly for the next tile. Their first products were adapt-

Two early Carter silk-screen printed tiles of c.1952: (left) from the 'Blue Dutch' series by Joseph Roelants; (right) a tile with a cupid and a dolphin.

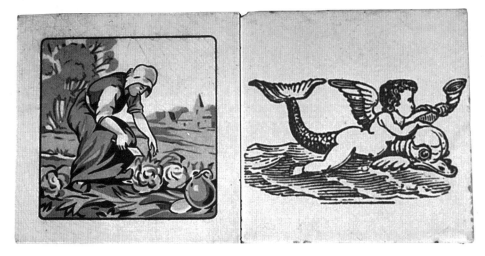

ations of pre-war hand-painted designs, but the rather mechanical appearance of these tiles and the demand for stronger patterns soon forced them to seek new designs from contemporary artists such as Reginald Till.

The catalogues of Carter & Company from the 1950s are filled with increasingly geometric designs by artists such as Peggy Angus, Ivor Kamlish, Robert Nicholson and Alfred Read. These often consisted of simple patterns that could be rearranged to achieve several different effects from a single tile or motif. Relief tiles were also produced with geometric patterns, covered with a single-colour all-over glaze, and these were particularly popular on the modular slabbed-concrete fireplaces that graced many homes during the 1950s and 1960s. One company specialising in these was Malkin Tiles Ltd.

This geometric approach to design was advocated in print as early

Above left: *Four Carter silk-screen printed tiles from the early 1950s. The top left tile was designed by Gordon Cullen.*

Above right: *Four Carter silk-screen printed tiles from the early 1960s. The tile top right was designed by Peggy Angus, and the one bottom left by Alfred Read.*

Left: *Four relief-moulded fireplace tiles by Malkin Tiles, 1954.*

Above left: *Four hand-painted tiles with heaped glazes and gold lustre, designed by Rhys and Jean Powell for A. J. Wade, 1957.*

Above right: *A silk-screen printed tile from 'Coloured Dutch' series designed by Joseph Roelants; Carter & Company, early 1950s.*

Left: *Two silk-screen printed tiles with traditional English scenes designed by Reginald Till for his own company, set up after he left Carter & Company in the early 1950s.*

Six silk-screen printed tiles with 'Pub Games' by Reginald Till; Carter & Company, early 1950s.

as 1953 when Mark Hartland-Thomas wrote an article for the August edition of *Design* magazine in which he illustrated a number of the new Carter designs and suggested that this approach was the way forward for the industry. He also showed similar designs by Pilkington's Tiles and Richards Tiles and some hand-made tiles by Steven Sykes in an unusual relief technique. However, he also showed a number of figurative designs, including a Coronation souvenir tile, commending it as 'a design very suitable for a tile'!

Tiles with these strong colourful designs were much used in the new towns constructed during the 1950s and 1960s, a prime example being Hemel Hempstead, Hertfordshire, which had a number of large-scale tile installations in bold geometric designs together with several modernistic murals. The only part of this scheme to survive is a tile mosaic by Roland Emmet situated on the side of a multi-storey car park. A number of kiosks on the sea-front at Littlehampton in West Sussex were faced with H. & G. Thynne tiles, but only one now has its

Below left: A hand-painted tile from the 'Pet Dogs' series designed by Margaret Matthews for Carter & Company, 1953.

Below right: King Lear from the 'Shakespearian Characters' series designed by R. Leeper for Packard & Ord, 1953.

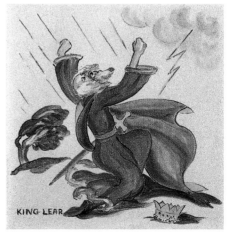

25

Two silk-screen printed abstract designs by H. & G. Thynne, early 1950s.

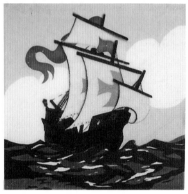

An H. & G. Thynne silk-screen printed tile, 'The Galleon', 1955.

original tiling. Public buildings were also faced with tiles, including a number of schools, government and local authority offices and health centres. To make the tiles suitable for external use, they were impregnated with silicone to stop water penetration and so prevent frost damage. This was not completely successful, and as a result few of these schemes have survived intact.

The hand-painted tiles of Packard & Ord of Marlborough, Wiltshire, were a notable exception to the trend towards geometric design. At the outbreak of war they had leased their kilns to a Dutchman for the production of charcoal, for use in the manufacture of explosives. In the process he completely wrecked the kilns for tilemaking, but despite this and the retirement of her partner, Sylvia Packard, Rosalind Ord decided to recommence tile

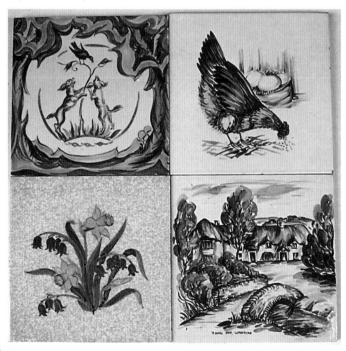

Four hand-painted tiles by Packard & Ord made between 1948 and 1955: (top left) 'Pastoral' series, designed by Sylvia Packard; (top right) 'Kitchen' series; (bottom left) 'Spring Flowers' series, designed by Rosalind Ord; (bottom right) 'Inns' series.

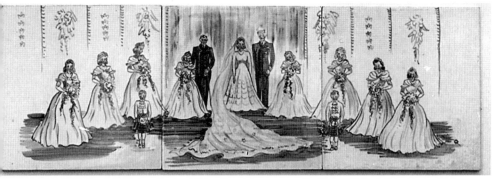

A Packard & Ord tea-tray panel commemorating the royal wedding, 1947.

decorating in 1946. She enlisted the aid of her neighbour Hugh Robb, who suggested making the tiles into tea trays, using a simple oak moulding, in order to avoid the huge purchase tax on decorated tiles. Robb had connections in London, and he began to market the trays to a number of prestigious outlets, including Fortnum & Mason. By 1951 the company had a thriving business in these tea trays and produced about twelve thousand that year, employing some ninety paintresses. As restrictions were relaxed in the mid 1950s, the company was able to revert to producing decorative tiles for kitchens, bathrooms and fireplaces. The company specialised in producing series of picture tiles covering a diverse range of subjects, such as 'Dickens Characters', 'Funny Animals' and 'Hedgerow Flowers'.

Although their production was never on the scale of Packard & Ord's, Dunsmore Tiles of Kensington, London, who had produced a

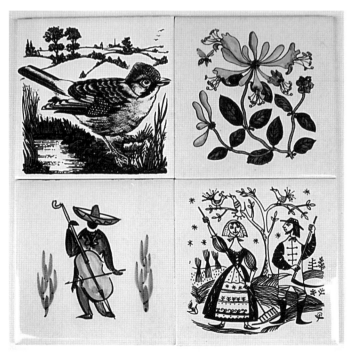

Four tiles of the early 1960s by Dorincourt: (top left) 'British Birds' series; (top right) 'Country Flowers' series; (bottom left) 'Mexican Peasants' series, painted by Alistair Metcalf; (bottom right) 'Rustic Peasants' series.

27

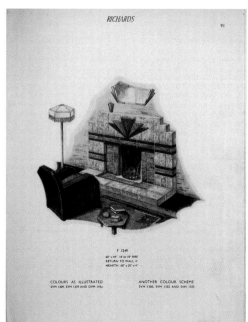

F. 1249
60" x 44". 16"or 18" FIRE
RETURN TO WALL 4"
HEARTH 60" x 20" x 4"

COLOURS AS ILLUSTRATED
SVM 1309, SVM 1339 AND DVM 1454

ANOTHER COLOUR SCHEME
SVM 1350, SVM 1352 AND SVM 1325

substantial range of hand-decorated tiles in the 1930s, also continued after the war. It seems production was dormant during the 1940s, but the company was working again by 1950, when they introduced a range of designs based on C. F. A. Voysey's illustrations for *Alice in Wonderland*. The company's lively designs were probably stencilled, but the exact technique by which they decorated Minton and other tiles has yet to be established. Fish designs were also popular, and these graced many luxury bathrooms installed during the 1950s. Dunsmore Tiles ceased trading in 1956.

Another company to decorate commercial tiles was Dorincourt Potters. Formed just after the Second World War to provide employment for disabled men and women, the company started decorating tiles in 1956 using outlines silk-screen printed by hand, combined with hand-colouring. The pottery was managed by E. W. Pritchard, whose monogram is

Above: *A page from a 1952 Richards Tiles catalogue showing a tiled fireplace as part of a domestic setting. Prewar Art Deco influences are still discernible.*

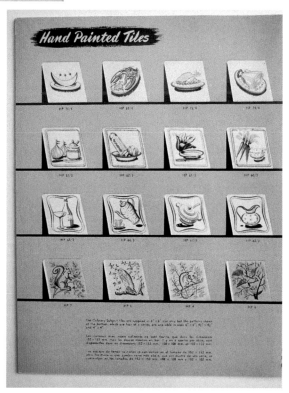

Right: *A page from an H. & G. Thynne catalogue illustrating hand-painted tiles typical of the 1950s.*

Two pages from a 1956 H. & G. Thynne catalogue showing a range of abstract silk-screen printed tiles.

found on many of their early designs. The business was non-profitmaking but traded as an ordinary firm in open competition with other manufacturers. The silk-screens for the outline printing process were produced in-house by the artists themselves, and all their other equipment was made by disabled employees too. Most of Dorincourt's designs were produced in series such as 'Wild Flowers', 'Tropical Fish' and 'Alpine Peasants'. The company also made a range

Below left: *A hand-painted tile with a scene from Widdycombe Fair; Packard & Ord, early 1950s.*

Below right: *A hand-painted commemorative tile for the coronation of Queen Elizabeth II, by Packard & Ord, 1953.*

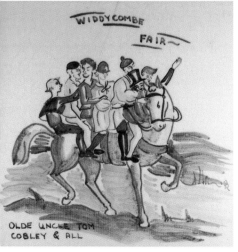

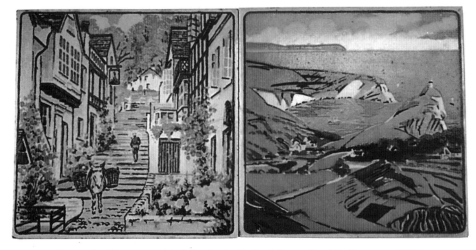

Two early silk-screen printed tiles by the Purbeck Decorative Tile Company, 1955-6.

of entirely hand-painted tiles, designed and executed by the talented artist Alistair Metcalf. These include floral, figurative and abstract designs in bright colours. His tiles are usually marked with an endorsed signature stamp on the back. Dorincourt is one of the few smaller companies to survive to the present day, manufacturing screen-printed promotional tiles and souvenirs.

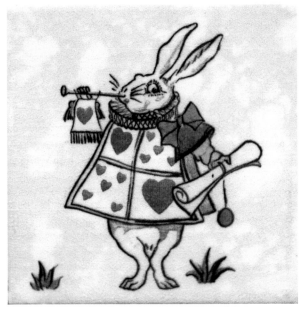

A tile from the 'Alice in Wonderland' series; Dunsmore, 1955.

LATTER-DAY DIVERSITY

As the period of post-war austerity drew to a close, so tastes in tile design changed. A major reason was the introduction of cheap foreign travel in the form of the package tour, with Italy and Spain being popular destinations. The colourful tiles that visitors encountered there were in sharp contrast to the traditional British tile. The major English manufacturers, H. & R. Johnson and Pilkington's, however, were slow to respond to the demand for new designs and continued to manufacture pale-coloured tiles in a limited range of shades that matched the colours of contemporary sanitary ware: primrose, pink, blue, and later pampas and avocado. The designs on such tiles continued to be produced by silk-screening, but the introduction of a wax-resist technique in the mid 1960s gave a slight relief effect to the surface of the tile when glazed. Typical of such tiles were the 'Vanity Fair' and 'Texture Vein' designs by H. & R. Johnson, both of which continued in production for some thirty years. Other manufacturers were no more inventive, and similar designs were produced by Pilkington's and the Newton Abbot firm of Candy & Company.

Although tiles were still largely the domain of the builder, in the 1960s increasing numbers were being sold to the burgeoning 'do it yourself' movement, stimulated by popular television programmes in which an expert showed the layman the tricks of the trade. The job was made even simpler by the introduction of ready-mixed tile adhesives, which rapidly superseded cement as the fixing medium for ceramic tiles. H. & R. Johnson and Pilkington's investigated new clays and firing techniques that enabled them to produce thinner, more precise tiles that could be cut and fixed by the average handyman. These tiles were also made with 'spacer lugs', which helped to ensure an even gap between adjacent tiles. Thinner tiles cost less to transport, and this further helped to bring tiles within reach of more people.

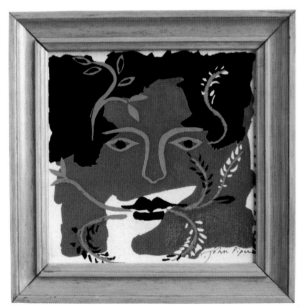

To cater for the DIY movement, shops specialising in tiles began to appear in high streets, another trend forecast by Mark Hartland-Thomas in his 1953 article. This was slow to happen, however, partly because of the restrictive trade practices maintained by tile manufacturers and wholesalers. These, as well as public demand, forced tile specialists to look abroad for supplies of more exciting, colourful and unique tiles. Soon Italian and Spanish tiles dominated the British market, and tiles from even further afield, for example Brazil and Mexico, began to appear

A silk-screen printed tile designed by John Piper; part of a set of four depicting the seasons, 1983.

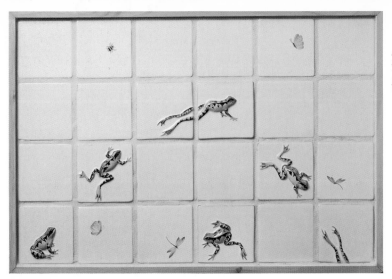

A panel of moulded relief tiles entitled 'Leap Frog', by Marlborough Tiles, Wiltshire, 1992.

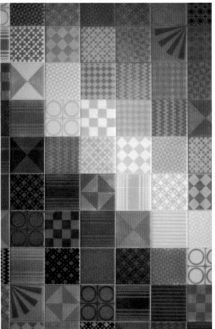

Left: *A set of silk-screen printed and hand-sprayed abstract tiles by Kenneth Clark Ceramics, early 1980s.*

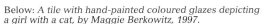

Below: *A tile with hand-painted coloured glazes depicting a girl with a cat, by Maggie Berkowitz, 1997.*

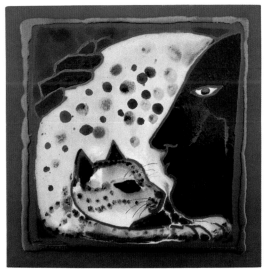

in high street tile shops.

During the 1960s H. & R. Johnson expanded rapidly and took over many of the familiar names of the past, including Richards Tiles, Minton Tiles and Maw & Company, most of which were gradually closed down. Pilkington's Tiles also consolidated their market share by merging with Carter & Company of Poole. Pilkington's specialised in wall tiles, but Carter made both wall and floor tiles, so the two companies complemented each other. H. & R. Johnson and Pilkington

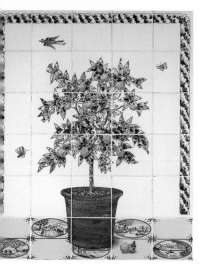

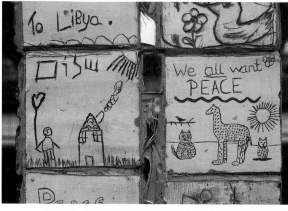

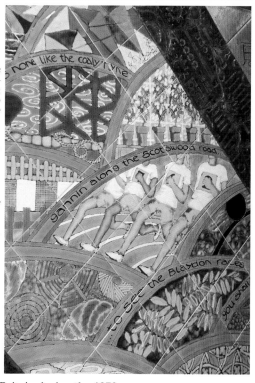

Above left: *A Delft tile panel made in 1995 by Jones's Tiles and showing an orange tree in a flowerpot standing on a ledge of traditional delftware tiles. This is an original contemporary design that also manages to acknowledge a historical dimension of delftware tile production.*

Above right: *Incised tiles made by children under the direction of Teena Gould for a community project, 'Tiles for Peace', Swiss Cottage Square, London, 1987.*

Right: *Detail from a tile panel entitled 'Bridges of Friendship' made by the British artists Christine Constant and Jane Hufton in co-operation with the Japanese artists Shuhei Koshita and Junko Tokuda for the Gateshead Community Centre on Tyneside, 1995.*

& Carter dominated the production of tiles in Britain during the 1970s although a few smaller companies tried hard to compete. Among these were Candy & Company and Packard & Ord, now trading as Marlborough Tiles. Both owned workshops where their tiles were slabbed up into the familiar fireplaces of the 1950s and 1960s.

In the 1960s, to satisfy demand for the new, more colourful tiles, a number of small-scale tile manufacturers were established who developed new and exciting glazes and decorating techniques that could compete with the imports from abroad. Kenneth Clark opened a studio in London, where he developed a range of tiles decorated with thick vibrant glazes. Patterns included bold butterflies across four

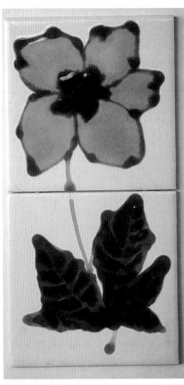

A two-tile floral panel designed and painted by Ann Clark; Kenneth Clark Ceramics, 1971.

tiles, purely abstract designs and a range of stylised floral designs. Kenneth Clark Ceramics continue to produce tiles, and their work is still much sought after today. Other successful small companies included Rye Tiles of East Sussex, with a wide range of hand-painted designs, and Eleanor Greeves of London, who specialised in screen-printed tiles.

In the early 1980s the changing economic climate and incentives from central government encouraged the establishment of smaller tilemakers who could produce one-off schemes designed specifically for a set location. One of the most successful of these new craft tilemakers was Maggie Berkowitz, who still specialises in unique tile panels using rich colourful glazes, often with slip-trailed outlines. Her intuitive use of colour has made her work sought after around the world. Her major commissions include panels for Great Ormond Street Hospital for Sick Children in London and a number of schools, conservatories and entrance halls in the United Kingdom, France, the United States and Japan. Sally Anderson Ceramics was another company established in the early 1980s that specialised in tiling whole walls or even rooms, often with a *trompe l'oeil* effect of ancient ruins and such like. The Purbeck Decorative Tile Company is an example of a small firm working in a very

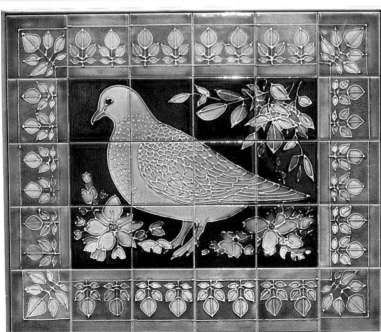

A tube-lined pigeon panel designed and made by Ann Clark; Kenneth Clark Ceramics, early 1980s.

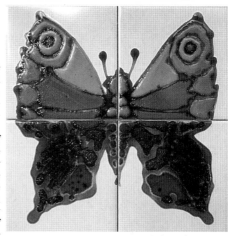

A four-tile 'Butterfly' panel by Kenneth Clark, 1965.

different style, but producing an exciting range of designs in the craft tradition. In addition there are Jones's Tiles and New Castle Delft, who offer an intriguing range of fresh reinterpretations of tiles in the delftware tradition.

Also in the 1980s there were a number of community tile projects in which local people designed and made tiles that reflected their community. One successful example was the scheme carried out in 1987 for Swiss Cottage Square, London, where local schoolchildren and groups from the ethnic community worked together under the guidance of ceramist Teena Gould to create a 'Tiles for Peace' mural. Although many of these community projects were designed and carried out on a shoe-string budget, an example at Gateshead, undertaken in 1995, was funded through a cultural and artistic exchange with Japanese artists under the auspices of the Komatsu Corporation. Two artists from each country participated: Christine Constant and Jane Hufton from the United Kingdom, and Shuhei Koshita and Junko Tokuda from Japan. The panel depicts images of the two cultures linked by the Tyne Bridge and a traditional Japanese bridge.

Paul Scott, another contemporary artist of note, created a number of striking tile murals for schools, hospitals and museums throughout the 1990s. A distinctive feature of his work is the inclusion of printed images in his hand-painted panels. Margery Clinton has undertaken commissions for schools and colleges

A hexagonal tile by Francesca Bennett for Fulham Pottery, 1988.

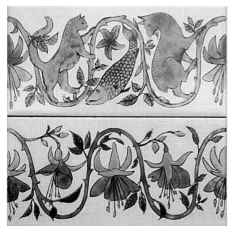

Two border tiles by Ann Clark, printed and coloured, 1990.

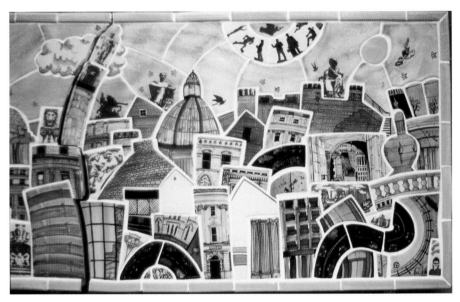

Above: *Detail of a tiled panel made by Paul Scott for the Royal Victoria Infirmary, Newcastle upon Tyne, painted in under-glaze on porcelain with screen-printed in-glaze details, 1998.*

Right: *A tile panel decorated in a cuerda seca (wax-resist) technique by Bronwyn Williams Ellis and showing two wrestlers, 1988.*

Below: *A tile with a flower design, decorated with slip and coloured glazes, by Margery Clinton, 1990.*

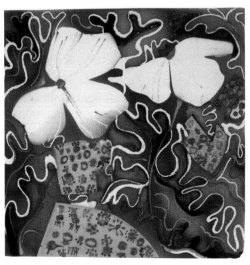

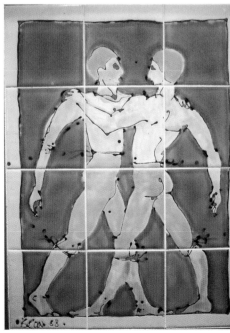

36

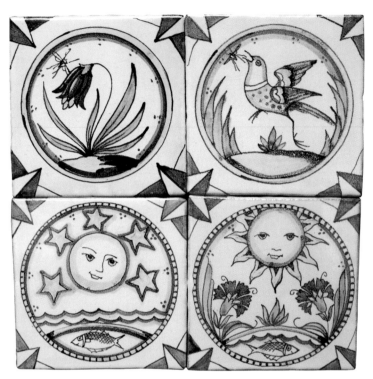

Four tiles from the 'Cosmos' series designed and made by Stephen Cocker and executed in a tin-glaze technique, 1991.

and creates exciting one-off single tiles painted in a free and spontaneous style. She also makes tiles inspired by the Arts and Crafts and Art Nouveau movements.

The 1990s were marked by major changes in tile retailing, with colourful brochures showing customers harmonised room settings. This marketing strategy was brought to Britain from the United States, where the industry is composed of many small manufacturers, with few national suppliers. One of the first such companies in Britain was Fired Earth, established in the mid 1980s to sell terracotta floor tiles salvaged from old French houses. As the business expanded, they introduced new and unusual tiles, often from smaller manufacturers, and diversified into natural floor coverings and paints in order to offer completely integrated interiors.

At the close of the twentieth century, tile design returned to the Victorian and Art Nouveau periods for inspiration, and companies such as Original Style offer a comprehensive range of transfer-printed, inlaid and moulded tiles, thus bringing twentieth-century tile design full-circle. 'Diversity' and 'choice' are the watchwords of the late twentieth-century tile scene, where large manufacturers, small companies, innovative retailers and tile artists sustain a buoyant and expanding market.

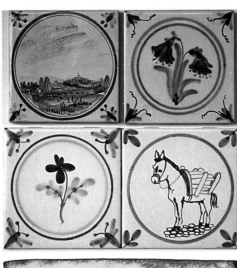

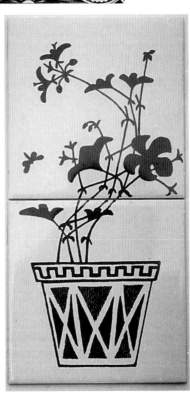

Top: *Two reproduction Victorian tiles by Original Style, 1992.*

Centre left: *Four hand-painted tiles from Rye Pottery, mid 1970s.*

Above: *A hand screen-printed tile panel by Eleanor Greeves, 1990.*

Left: *A hand-made and hand-painted tile by Suzanne Katkhoula, c.1990.*

FURTHER READING

Austwick, J. and B. *The Decorated Tile*. Pitman House, 1980.

Blanchett, C. 'Picture Tiles in the Twentieth Century' in *Fired Earth – 1000 Years of Tiles in Europe*. Richard Dennis, 1991.

Cross, A.J. *Pilkington's Royal Lancastrian Pottery and Tiles*. Richard Dennis, 1980.

Hayward, L. *Poole Pottery – Carter & Company and Their Successors, 1873-1998*. Richard Dennis, 1998.

Huggins, K. 'Contemporary Tile Artists' in *Fired Earth – 1000 Years of Tiles in Europe*. Richard Dennis, 1991.

Lemmen, H. van. *Decorative Tiles throughout the Ages*. Bracken Books, 1989.

Lemmen, H. van, and Verbrugge, Bart. *Art Nouveau Tiles*. Laurence King, 1999.

Rasey, S. *A Brief History of 'Marlborough' Tiles and Tile Products 1936-1986*. Marlborough Tiles, 1987.

Scott, P. *Ceramics and Print*. A. & C. Black, 1994.

Siegal, R. *Decorating with Tiles*. Columbus Books, 1989.

A late Art Nouveau tile; Malkin Tiles, c.1910.

39

PLACES TO VISIT

Visitors are advised to find out the opening times before travelling.

Jackfield Tile Museum, Jackfield, Telford, Shropshire (part of Ironbridge Gorge Museum). Telephone: 01952 882030.

People's Palace Museum, Glasgow Green, Glasgow G40 1AT. Telephone: 0141-554 0223.

Poole Pottery Museum, Poole Pottery, East Quay Road, Poole, Dorset BH15 1RF. Telephone: 01202 669800 (tours) or 01202 666200.

The Potteries Museum and Art Gallery, Bethesda Street, Hanley, Stoke-on-Trent, Staffordshire ST1 3DE. Telephone: 01782 232323.

Victoria and Albert Museum, Cromwell Road, South Kensington, London SW7 2RL. Telephone: 0171-938 8500.

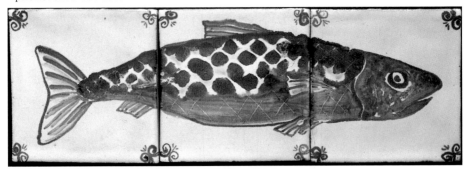

A Delft tile panel with a fish by Charles Allen executed in a tin-glaze technique; New Castle Delft, 1995.

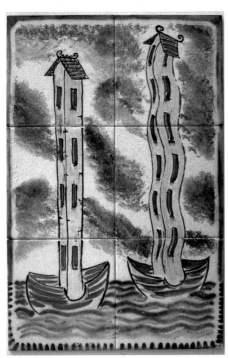

Left: *A panel with lighthouse boats designed and painted by Charles Allen in an under-glaze technique; New Castle Delft, 1997.*

Below: *A tin-glazed painted tile with a fish; Jones's Tiles, c.1995.*

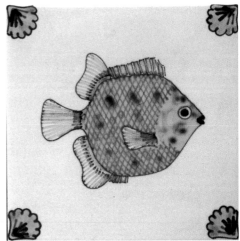